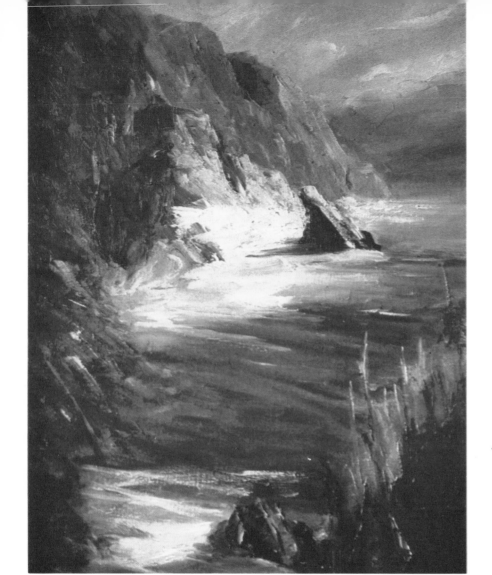

JEAN KHANBEGIAN

PAINTING
SEA
AND SKY

Publishers • Grosset & Dunlap • New York

A Filmways Company

Yea, unconquerable Sea
I fear thee
Though with thy depths
I need thee
Thy rock-strewn shores
and pounding, bores
With never-ending song . . .
PAPKEN

F O R M Y F A T H E R

All rights reserved
Published simultaneously in Canada
Library of Congress catalog card number: 66-24004
ISBN 0-448-00566-2
1977 Printing
Printed in the United States of America

CONTENTS

Cover painting is *Winter Sea;* painting on page 1 is *Evening Tide.* Both paintings by the author

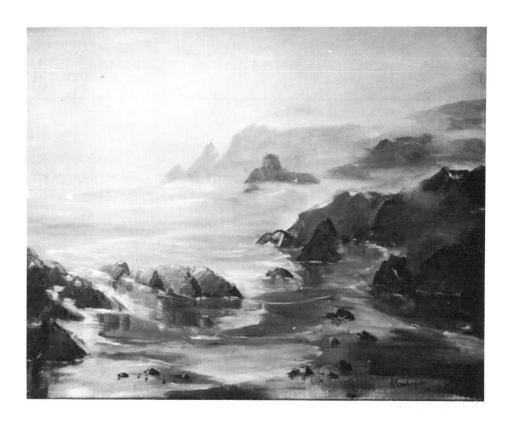

The Sea

I think I have always painted the sea. To me, it is an integral part of my own personal self-expression. At times the sea is lonely, but not with the loneliness of absence. Rather it is a oneness—an affinity. I love its moods—even on greyest days—most of all on greyest days when the long, low mists roll in from the headlands to dim the ragged shoreline imperceptibly. One who has lived by the sea can never again be free of it. So it has been with me.

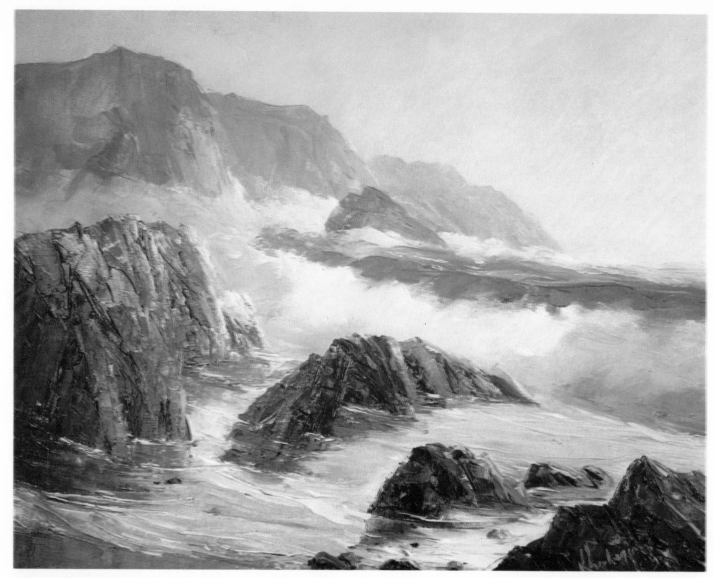

Atlantic Sunrise.

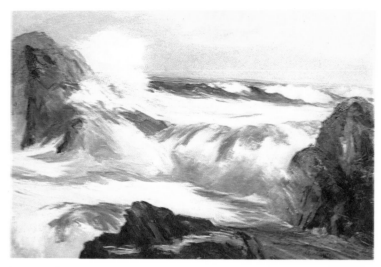

Summer Sea.

Understanding the Subject

The sea is a difficult and challenging subject for the painter, but an enormously exciting and versatile one. Because of the moods and mystery which have surrounded it since the beginning of time, the sea offers many opportunities for creative interpretation, and has appeal for both the representational and abstract painter.

Since we are concerned here with ways of painting the sea and sky, it would be helpful to first point out some of the factors which will help the artist understand the subject—for understanding the nature of the subject is the first requisite for developing an approach to it.

The patterns of coastal waters are strongly affected by a series of gradations, ledges and rocks, which often are not visually obvious to the artist. However, it is the rocks lying *under* the surface of the water, as well as those above, plus the currents and undertows, which will strongly influence the sea's great fluid motion. Light and fluctuating winds must also be taken into account. They all play a primary part in creating surface patterns so vital and important to the design and concept of a painting.

The sea can be notoriously uncooperative—it will never hold its pose as the model or still life will. Unsuspecting tides will creep in and completely wash over the interesting group of rocks that may have been the focal point of your painting. Sudden fog banks may drift in to obliterate all but your immediate foreground, or shifting winds may alter the surface completely. All of these things contribute to the artist's discomfort and complete frustration.

It seems, then, that the only way to beat the elements is to acquire as much knowledge and understanding of the subject as possible beforehand. Observation and many careful sketches will help to make this understanding possible, and will also develop your own power of analysis.

In the following sketches, I have illustrated some basic points to help you become aware of the rhythms and harmonies that exist around coastal waters. Look for these things and incorporate them into the basic design of your composition. Once you begin to *see* or become aware of them, you will never be guilty of painting rocks that seem to float on top of the water, or portray a body of water as a solid heavy block of color. It should be remembered that water is *not* a solid mass, but a moving fluid thing. Its motion is constant, even on days when there is hardly any wind.

Note the curve of the water in Figure 1 as it rounds the jagged rock in the upper righthand section. Water in itself is inanimate and moves only because of external forces. Therefore, as this great mass is pushed forward by the wind, its direction is abruptly altered by an opposing wall of rock. This immediately changes its direction. The pattern of the water is changed again by the rocks whose uneven surfaces are just under the water in the right foreground. The whole movement of water now takes on a subtle rhythm of relating lines. After making these analytical observations, the water pattern's curve can be brought out or strongly accented, and thus play an important role in the painting's inherent design. An entire composition could be built on this one line.

The sketch in Figure 2 further illustrates underlying causes affecting surface patterns. Here we see water washing back in

Figure 1.

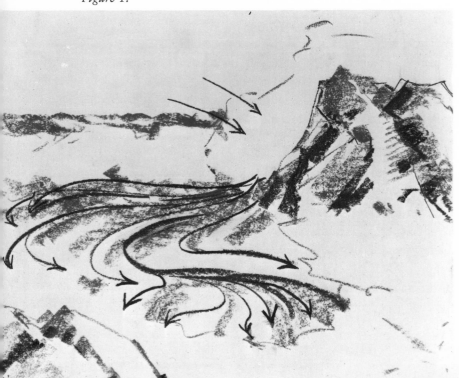

Figure 2.

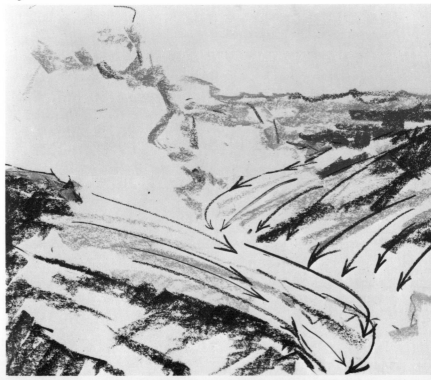

opposing directions from two rocks rising above the water's surface. This creates a slight undertow, and may be interpreted in a manner suggesting great design possibilities for a strong, interesting foreground.

The third sketch (Figure 3) illustrates still another schematic movement that must be taken into account—the backward flow and pull from the shoreline created after a wave has been dissipated. This backward pull also creates an undertow that is always present in coastal waters. There is an ebb and flow here with one line relating to another.

The foamy lace effects of the churning water or dissipated wave in the fourth sketch (Figure 4) depicts still another type of surface pattern. (Note foreground in sketch.) This is especially effective when combined with light effects or dull greys, or used to simply add a restful passage in a very busy or active sea.

These sketches represent the merest fraction in the endless variety of movement and pattern existing in a coastal seascape. No two need ever be the same. However, one important factor must characterize and apply to all—there must be a relationship of one line to another. At times, this may be an unconscious or abstract phenomenon, but it does exist, and it must show through. Neglect of this point often results in the short agitated line, lacking both beginning and end, which artists sometimes use to depict movement or action along the shoreline. Think of the ocean in its entirety— a concentrated body of fluid material, connecting rather than dividing.

A wave should not be treated as a thing apart, but rather a shifting or movement within the mass itself. Once some of these basic factors that make up the essential character of the sea are understood, I am sure your painting will have the vitality, conviction, and strength of statement necessary to make it a success.

Figure 3.

Figure 4. Lacy Pattern from Foam of Wave.

Figure 5.

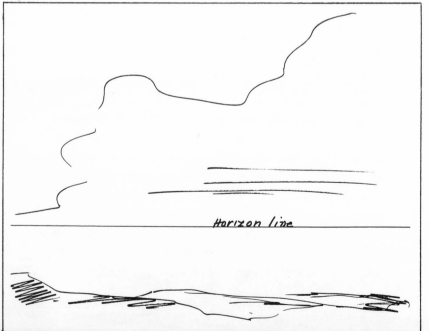

Horizon line

Figure 6.

Horizon line

Figure 7.

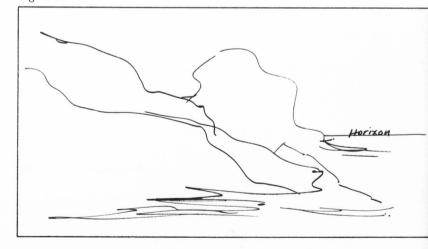

Horizon

I Remember Summer.

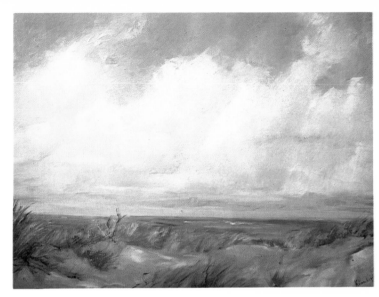

Composition

It is difficult to capture the expanse and magnitude of the sea on one small canvas. There is so much to see and so much happening that your enthusiasm may tend to run away with the painting. Since the dimension of your canvas, no matter how large, cannot compete with the vastness of your panoramic view, we must give the illusion of depth and distance, or a spatial "trompe l'oeil." One of the first things to consider is the fact that the horizon line in a seascape tends to cut the painting in two. Generally, you will find that the horizon of the landscape is broken or made uneven by mountains or distant trees. Not so in the seascape. As far as the eye can see, the level of distance is usually fixed on that straight and unyielding horizon line.

In order to overcome this unbroken line, but still retain the feeling of space, there are a number of things that can be done. First of all, if you must look straight out to sea, change your eye level so that your horizon line will not cut your canvas in the center but, rather, above or below. In other words, look at the view from either a higher or lower perspective (as from the cliffs above in the sketch in Figure 5 or from a lower level as illustrated in Figure 6). In this way you can divide the composition into two unequal parts, giving greater weight to either sky or water.

One of the best methods of composition, I think, is to select a view toward the shoreline with only part of the horizon line showing (see Figure 7). Here the vast open sea beyond is indicated, suggesting depth and distance without emphatically cutting the composition. Subtle suggestions are often very effective because they leave something unsaid and give the imagination more scope for the filling in of details.

Once your horizon line has been established, survey the scene before you, and decide what it is you wish to say. What do you

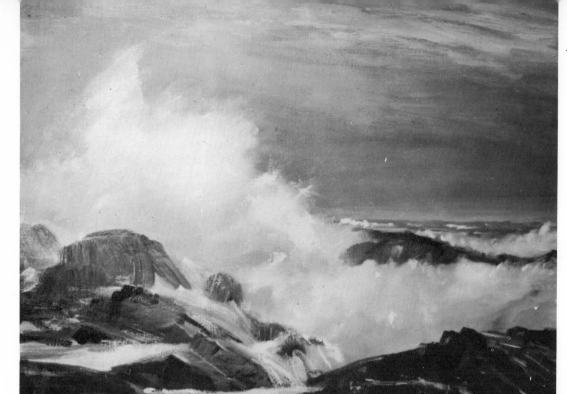

Breaking Wave.

wish to feature, and how can you best express it? There should only be *one* focal point of interest in the painting, with everything else merely relating to that point. Decide that either one particular wave catching sunlight at its crest, or the large group of rocks with the wave breaking over them will be the main theme of the painting. By selecting just one elemental statement to dominate your composition, the rest of the action should be subdued or merely suggested, so that it will not distract or lead the eye away from the main center of interest.

Foreground rocks afford many opportunities for good composition and can be used to frame in your center of action. They should be placed with strong well-defined lines suggesting weight, and textural qualities that contribute a feeling of stability and strength to your composition.

Work for contrast and avoid too much action between sky and water. The effect of billowy clouds and too much surf within the framework of one small composition will tend to give your work a confused and overstated look. Keep it as simple as possible, placing emphasis on either sea or sky, for a pleasing, harmonious effect.

Interpretation through Color

Once the problem of composition has been solved, the next step involves the color process or, deciding how the subject may best be interpreted in terms of paint and color. To this point, we have merely been concerned with a pleasing harmony of lines and the relation of one shape to another. Color is an entirely different aspect. First of all, it is personal: Generally, no two people see color alike. It may be used to express drama and excitement, or the sensory vibrations of mood and emotion that only you as a creative artist may contribute. Once you begin to see your subject or idea in terms of paint and form, you are beginning to acquire the vocabulary of art, which is as important to the artist's visual expression of himself as is language to the poet.

In this area, however, there are certain basic rules of discipline and good taste that should guide and influence your work. These include contrasts of cool color against warm, a play of complementaries against each other, and the painting of clean color tones, especially when working with dark or shadowy areas.

My palette is a fairly simple one, and works very well for me. You may use it as a guide, or discover combinations of your own. For example, many artists like to mix their own greens from various combinations of blue and yellow. I do on occasion, but generally find that viridian and oxide of chromium perform quite effectively and give me the results I want.

My preferences run as follows:

cerulean blue	raw sienna
cobalt blue	cadmium yellow pale
ultramarine blue	cadmium orange
Prussian blue (on occasion)	vermilion
viridian	alizarin crimson
oxide of chromium	raw umber
yellow ochre	paynes grey

You may have noted that I have eliminated the use of black altogether, and have the barest minimum of earth colors. Too many earth colors tend to muddy a tone. I also prefer to "grey"

my colors by using their complement rather than by using a grey made from black. For instance, a blue cut down with raw sienna and/or umber seems more enlivened than it does when black is added. Black seems to deaden the blue, as well as decrease its intensity. A combination of alizarin and raw umber, ultramarine blue and raw umber make deep rich blacks, although ivory black has its place on certain occasions—when used, for example, with sepia and white for a stylized, dramatic effect. The addition of yellow ochre or raw sienna to cobalt or cerulean will cut down the strong raw look of the unmixed blue, which is generally detracting in a sky. It will also add warmth.

Blues added to raw umber make the best "cool" shadows, especially when not mixed too thoroughly. When bits of raw color are allowed to show through, they will add sparkle and vitality to the dark and uninteresting portions of the painting. This is also true when painting warm shadows, except, of course, that here the warm colors, cadmium and alizarin, are added to raw umber.

There are no set rules for painting the sea—however, it should be remembered that water itself has no color, but reflects the elements which surround it. Thus, the sea will reflect the sky, the rocks, and, in many cases, the underwater terrain. For instance, where you find a sandy bottom, the breaking wave will sometimes take on a copper color, because sand is being churned up from the bottom. The crest of a wave breaking over a rocky bottom is usually a clear irridescent green—even on grey days. Without the sand to cloud its tone, it becomes crystal clear, and the imprisoned air within the wave gives it a jewel-like quality. I generally use a mixture of viridian green, cadmium yellow pale, and zinc white for this portion.

In the preliminary composition for *Atlantic Winds,* I shall try to cover some of the points we have covered so far as well as their practical application when applied to a typical seascape.

In this study, we have the approach. Study the scene before you and decide on the composition. At this point, I would suggest that you use a wide brush with a little color. I suggest the brush rather than a charcoal pencil because use of the brush tends to discourage small tight drawings and unessential details. It will give you greater freedom and a looser approach.

In the second stage of *Atlantic Winds* we concentrate on color values and the location of the warm and cool areas. You begin to lay in the underpainting thinly at this stage, indicating the darkest values first. For rocks not hit by sunlight, the tone will be cool, and here I have used a mixture of ultramarine blue, cerulean blue, and raw umber. Do not overmix, but allow the broken color effect of the raw blue to play up your cool tones and impart richness and sparkle. Here, also, I have incorporated a little of the viridian and oxide green used in the water next to it. This will help the color relationship as well as capture some of the light's reflection on the water. Note, too, the red touches on the rocks in the immediate foreground. The added touch of this juxtaposition of red and green can contribute a great deal to the color value of the rocks in your painting.

Where the rocks and surf catch the light, I have made it highest and lightest in key, with the warmest colors—cadmium yellow pale, yellow ochre, and zinc white—used for the surf. The yellows used here are used with restraint, however—just enough to lose the "mustardy" look, but enough to avoid a chalky one. They should be quite well mixed for this area, as compared with the broken color areas. The rocks in sunlight are a mixture of raw umber, raw sienna, yellow ochre, cadmium yellow, and orange. Some of the

Preliminary Composition for Atlantic Winds.

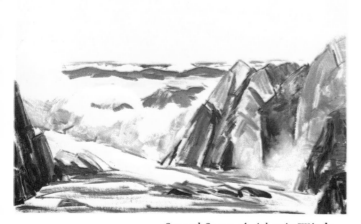

Second Stage of Atlantic Winds.

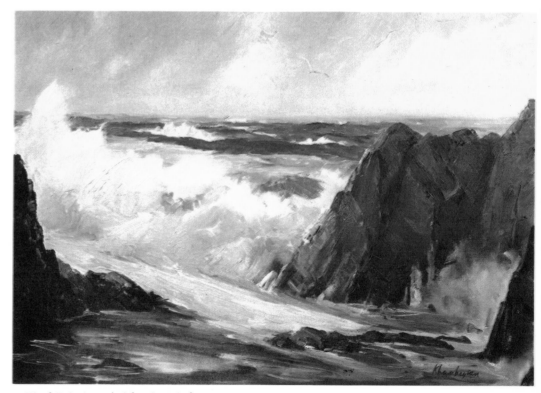

Final Painting of Atlantic Winds.

warm colors were also mixed into the cooler portions of the rocks at right. Thus, the warm reflected light from the left is suggested.

You should always be aware of "shadows in the light." Since they are not always apparent to the artist, especially when the sun is strong and his subject is constantly moving, he must learn to look for them. This introduction of a cool note to your warmest and highest key area will heighten the sunny effect and strengthen its form. When painting surf, the same rules of color and value must be observed and applied for character and symmetry, even though, to the untrained eye, there is a prevailing sense of "whiteness" as the large mass moves along with power and force.

However, you must remember that white embodies all prismatic color, and thus surf in sunlight will have strong warm accents of color, usually a mixture of zinc white, yellow ochre, or chrome orange, while its shadow portion, or lower half of the surf curving under, should be indicated with a mixture of paynes grey, cerulean blue, and zinc white. I stress zinc white because, of all the whites, I find that it yellows least.

The turning wave will always be highest and lightest in key the moment it curls over, due to the imprisoned air caught in the process. In *Atlantic Winds* I have indicated this portion with a mixture of viridian, cadmium yellow pale, and zinc white. Water in the middle distance, where it is deeper, is a mixture of viridian and oxide green, while the distance is indicated with cerulean blue, zinc white, and a small amount of alizarin crimson. The sky is quite "grey" cerulean and white, with a little yellow ochre added for warmth, and the clouds are painted with restraint to avoid a conflict with the water's fairly lively action. Thus, they are barely indicated.

In the final painting of *Atlantic Winds,* the indicated areas of rock have been built up, and final touches have been made with the palette knife for texture and style. Seascape painting lends itself well to an interesting variety and interplay of textures. There are the heavy, solid forms of rock contrasting with the finely diffused diaphanous spray. One suggests consistency and permanence—the other suggests restlessness and change.

I like to use an impasto technique when painting rocks as I have found the expressive quality of the palette knife very well suited to the interpretation of their intrinsic abstract qualities. Touches of white in the immediate foreground give the water movement and were brushed in delicately. The water in the middle distance was brushed in with a mixture of viridian and cobalt blue. The mist rising in the cove at the right is thinly painted and left practically untouched from the beginning. Birds are added last. The contrasts of texture and color give life and meaning to the painting.

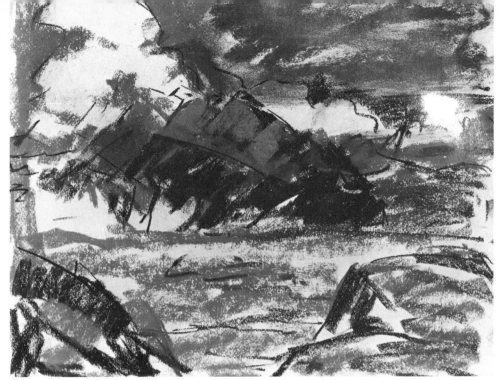

Figure 8. Sketch for Dusk.

Value of Sketching

It is not often possible to finish a seascape painting "on the spot." I have found that it is better to make analytical sketches on location and finish them up later at home or in the studio while the impression is still fresh, and the danger of distraction has diminished. For instance, as mentioned earlier, the discomforts and frustrations endured by the artist can be legion and, unfortunately, days when the surf is likely to be the most exciting are usually the days when gales and winds will be blowing the hardest.

Dusk was made from a very rough sketch (see Figure 8) and had to be painted practically from memory and a rough impression. It was possible to do this because of the previously acquired knowledge of the subject. There is little detail; one elemental statement tells the story. It was necessary to catch the last rays of the setting sun precisely when the high-flung surf broke on the reef. It was a dramatic and beautiful, but fleeting phenomenon, and had to be captured and remembered in a moment.

Figure 9 and Figure 10 were painted on the spot on small 8″ x 10″ panels. They are unfinished and concentrate on rock studies rather than sky or surf patterns. The rocks are painted fairly flat, and are indicated for patterns in an almost abstract manner. Bulk, weight, and color are noted and sketched in with paint applied with a palette knife. Small panels or canvases are helpful, as they fit into the paint box and are fairly easy to manage out of doors.

Sketching—all types, whether with pencil, pen or paint—is the best method I have found to sharpen your awareness, and develop your ability to quickly discern what is important and what is not.

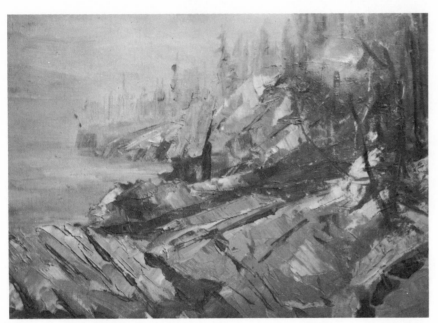

Figure 9. Rock Study.

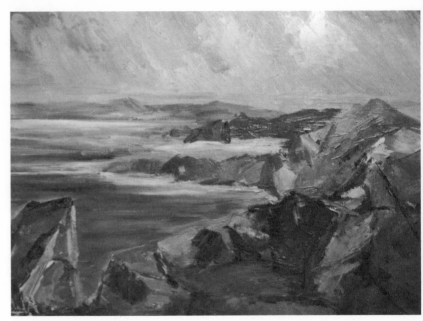

Figure 10. Rock Study.

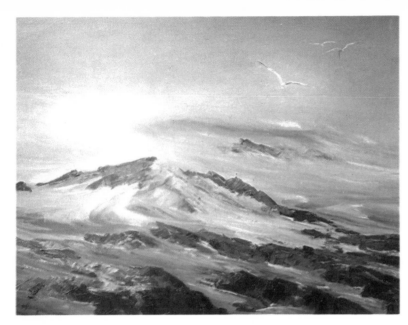

Autumn Seascape.

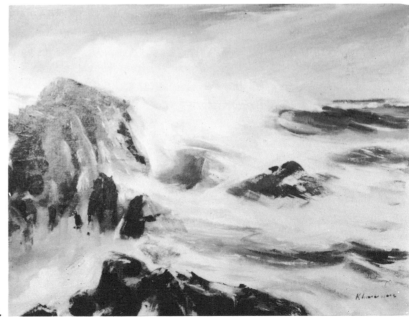

Equinox.

17

Skies

The treatment of the sky in a seascape is very important, as it sets the mood and determines the source of light. However, as mentioned earlier, care must be taken to avoid an overly "busy" sky when there is much activity in the water. By overly busy, I mean too many fluffy clouds which would conflict with a lot of foaming water. When there is much wave and surf activity, I usually try to paint a quiet, cloudless sky. My color combination for skies is cerulean blue, which is a good sky color because of its grey quality, added to zinc white as well as yellow ochre or alizarin crimson for warmth. As the sky drops down to the horizon, the color is a little pinker or warmer than the deeper blue of the sky just overhead, and the blue of the sky is always generally lighter in tone than the water which reflects it.

I try to minimize a blue sky whenever possible, and there are many ways to do this. Sometimes you may see a cloud bank settling on the horizon line. Since the cloud forms will be en masse rather than isolated, it is possible to use this grey background as a foil for the blue of the water—especially when the greys are warm. Sky at sunrise (*Atlantic Sunrise,* page 4) or sunset is also effective, although generally I don't prefer to paint either one of them show-

ing the sun. Beautiful though it may be in nature, it is difficult to paint it as such; more often than not, it tends to look overstated and "calendarish" when reproduced in paint.

It is possible, however, to paint a lovely warm sky just as the sun is beginning to lower. Some of the intense blue is gone, and the sky picks up some warm golden light. If you wish to paint the fleecy clouds in a summer sky, then you should allow the sky to contribute all of the activity to the scene, subduing the action of the sea. This makes for a more harmonious distribution and composition.

I Remember Summer (page 9) is an example of a seascape where, although most of the action takes place in the sky, we are still very much aware of the sea, the wind, and the warm light typical for this sort of day. These are cumulus clouds. They are constantly moving, and have three dimensions—bottom, side, and top. Cumulus clouds are quite thick at the bottom, near the horizon, and thinner in the upper portions which explains their dense appearance as they descend to the horizon. The shadow on the bottom is the lower part of the cloud as it shades back into the shadow. Near the top the clouds are rather vaporous and wind-tossed.

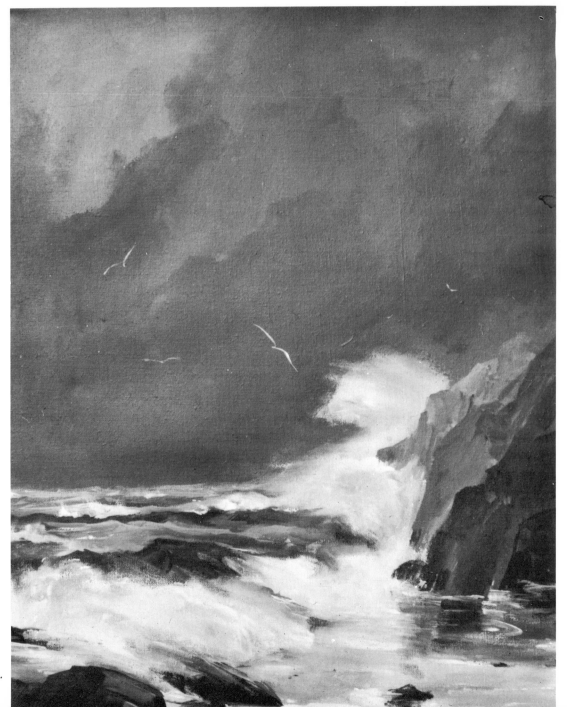

Restless Tides.

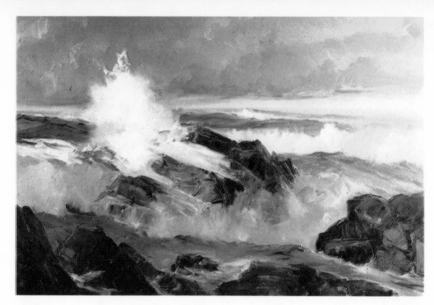

Dusk.

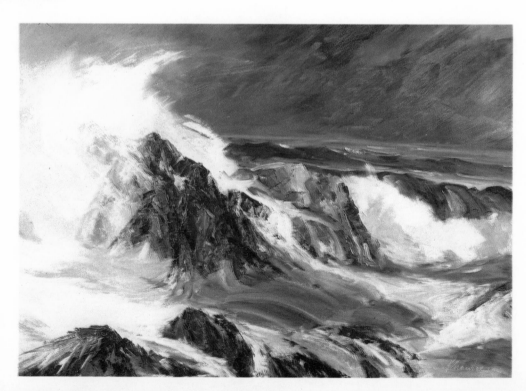

Winter Sea.

As in painting surf, the white is not really white but a gradation of light and shade. The shadow side is painted with paynes grey, cerulean blue, yellow ochre, and zinc white. The highlights which reflect the sun are zinc white with cadmium yellow pale and yellow ochre. The blue of the sky above the clouds is a mixture of cerulean and cobalt, with some added touches of yellow ochre.

In the painting *Winter Sea,* the sky is overcast and ominous. Prussian blue, which is an intense greenish blue, is the predominant local color and is exaggerated slightly to emphasize the pale light of a winter afternoon. The sky is subdued giving way to the furious action of the water, but we are aware of its cold and sombre mood.

On the other hand, the sky in *Rain Shadows* is also heavy and overcast. It is a rainy sky, but not quite so sombre and brooding. The clouds, hung low, are typical of a late afternoon shower. The sky is patchy in places, allowing some light to filter through, and the accents of cadmium orange and yellow ochre on the buildings add warmth to the damp and chilly scene. The sky dominates. Man is small; his strength pitted against the vastness of the elements, he seems dwarfed and unimportant. The sky sets the mood which is quiet and reflective. Only a few colors have been used for the painting—paynes grey, raw sienna, cadmium orange, yellow ochre, and cerulean blue.

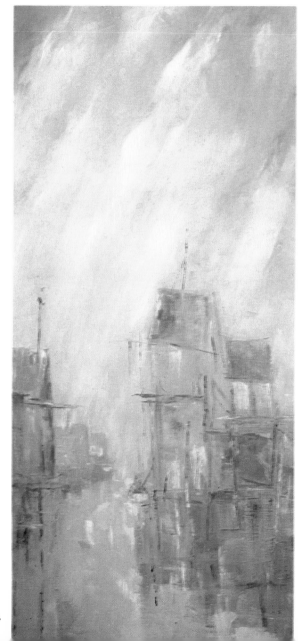

Rain Shadows.

21

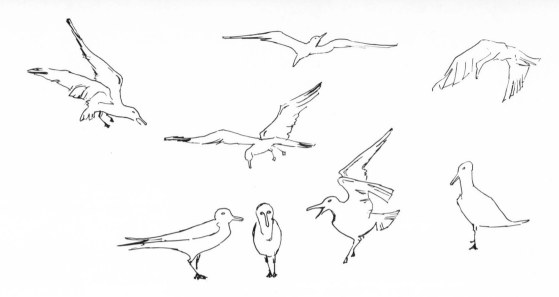

Figure 11. Gulls.

Seagulls

It is impossible to think of skies without birds. Seagulls are as much a part of the coastal scene as the sky and wind itself. They are always present, but the artist usually chooses where or when to include them in the painting. In some painting where there is a great deal of activity, the added movement of the gull may seem superfluous. However, in a painting with less action, they will contribute strongly to the life of the composition. See *Fog Drifts Inland* (page 28). Sometimes, they make such a fuss that they demand to be painted—at other times, they stand regiment-like on top of a fish shack or barn, and make an interesting and amusing factor for design. At any rate, the beauty and personality of the gull is not to be overlooked.

The species may vary from coast to coast, but I believe the gulls most familiar to us are the kittiwakes (Figure 11), the herring gull, or the glaucous gull. To me, the kittiwakes are the most graceful of all; at least they are the most hardy and adventurous, having been known to follow a ship out to sea as far as the Continental Shelf.

Kittiwakes (so called because of their cry) are white with palest grey wings tipped with black as though dipped in ink.

When painting gulls, it is best to present them at varying angles for interest. Many artists are inclined to paint them all flying the same way. Observe and study carefully the anatomy of the gull—the strength of the chest that seems to jut forward as if to brace the bird against the lash of the ocean gale. There is tenacity in the webbed feet, and the legs retract in flight like the landing gear of a modern plane.

The legs should be well placed toward the lower end of the

body. Too often they are carelessly drawn, protruding somewhere from the center of the abdomen, giving an awkward, off-balance look to this most graceful of birds. Notice how the bill is designed to scoop up fish and other organic matter from the shores and water. The gull swoops down with hawk-like precision to fetch his food.

Although the body of the seagull may seem round and full, especially when compared to the tapered wing, it is better to slim it down a bit for the sake of line and grace. Since it may be difficult at first to sketch the gull in motion, it might be helpful to work from photographs. However, the camera is often deceptive and may seem to foreshorten or add pounds. When thinking of the gull in flight, it is always its beauty, grace, and symmetry that come to mind. Observe and sketch them when near the shore, so that your references will merely serve to refresh that wonderful image.

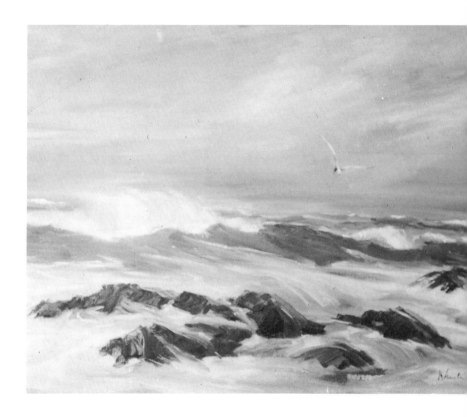

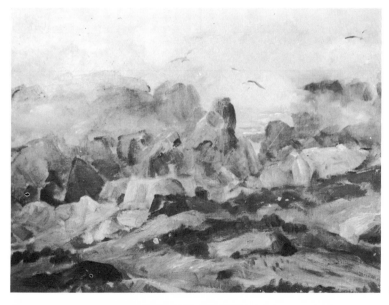

Gulls over "Black Rock."

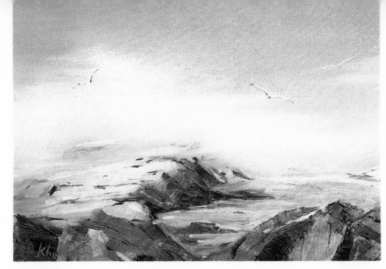

Grey Dawn.

Atmospheric Effects

LIGHT

Different kinds of light and atmospheric effects contribute mood and drama to a painting. It is very difficult to paint or even sketch in the rain, but try to get out and observe the sea and sky under various weather conditions as much as possible. Warm light on a sunny day is pleasing, and there will be strong contrasts of light and shade. This is particularly evident in the early morning just before sunrise, or in the late afternoon before the sun sets. Shadows are usually well defined and longer then; rocks, caught in various lights, create patterns of unbelievable beauty and form. Light is sometimes cold and bleak, as in *Winter Sea* (see page 20). Its source is the upper left-hand corner, and it is thinly sifted through the overcast, gloomy sky. It shines directly on the rocks, but fails to warm them, and the mood is raw and biting.

The term downlight is sometimes used to describe the diffused light of a rainy or misty day. Here you are not aware of any direct source of light but, rather, all surfaces facing the sky seem to reflect it. *Quarry-Point Road* (see page 30) illustrates diffused downlight. The wet puddles on the old road, the tops of the houses and flat rocks, all reflect the sky. In *Grey Dawn,* there is also a thinly-diffused downlight striking the tops of the rocks in the center and to the right. The water is calm as it usually is in the early morning when the mist rolls in.

Moonlight, because of its very nature, is always dramatic. It emphasizes, and sometimes barely rimlights, form as in *Nocturne I.* In *Nocturne II,* the source of light is more obvious, as it just begins to break through the clouds. Both these moonlight scenes were painted with combinations of Prussian blue, paynes grey, ray umber, and raw sienna, with touches of cadmium orange in the foreground rocks. Since my objective was to portray a soft, balmy summer night, the addition of some warm color takes away from the coldness of the blues.

Nocturne I.

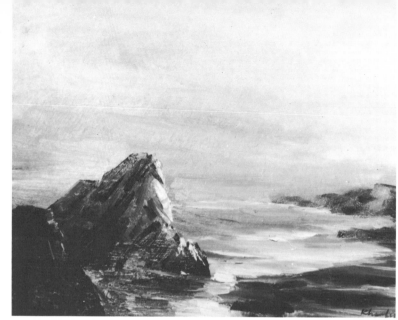

Nocturne II.

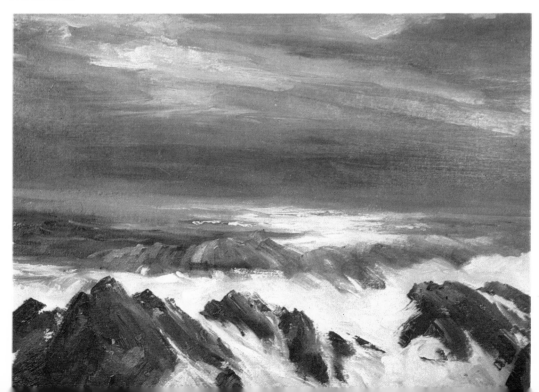

WIND

There is, almost always, some wind near the shore. An awareness of the wind's presence is essential because it should have a tactile influence on your painting. It may be a hardly noticed surface wind skimming the water to barely ruffle it. Then again, the wind may be offshore. When it is, there is a noticeable backward flying of the fine surf, especially as the wave plunges forward.

When the wind is blowing in from the sea, however, the waves will be much higher, and will have a crashing surf. Many times, these high waves are caused by strong winds far out at sea. These disturbances are felt hundreds of miles beyond their place of origin. For example, the California coastline has often been lashed by heavy seas resulting from hurricanes or tropical storms around Hawaii. This explains why the day after a hurricane is often enjoyable for painting: There is considerable movement in the water, but the discomfort of a high coastal wind is absent.

Waves, or water that moves along with a strong wind behind it, become a tremendous force. As the wave is pushed along, it picks up velocity and height as well as stones, driftwood, and everything that may be in its wake. Its impact on the cliff and shoreline is powerful. Large caverns or indentations are soon carved out, and new beaches are built up. Thus the wind plays a great determining role in the ever-changing face of the land.

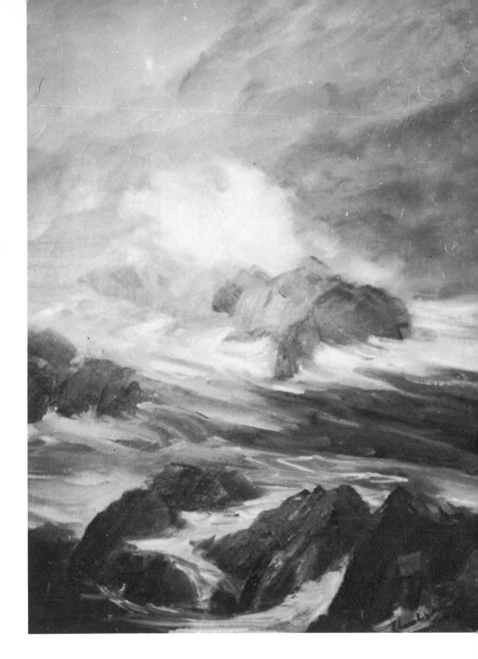

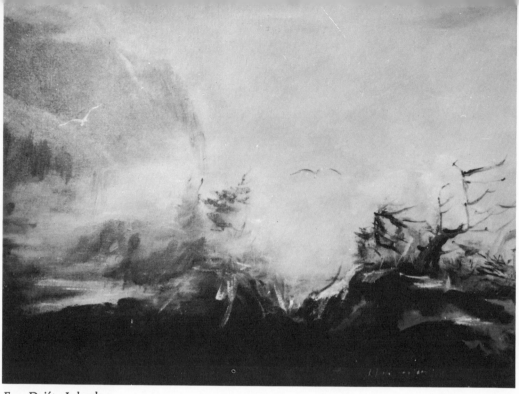

Fog Drifts Inland.

RAIN AND FOG

There is a mysterious, haunting quality in the mist that rolls in from the sea and, somehow, it seems to characterize the coastal scene better than any other ingredient. The effect of half-shadowy form and color which seems constantly to turn and shift is startling and almost unreal.

In the painting *Fog Drifts Inland,* I tried to capture the silent, gentle, and almost isolated mood of an island forest. The ragged scrub pines, no longer sharply etched, take on a stark, phantom shape, and a kind of pleasant melancholy—remote and detached—pervades the scene.

Rain and fog can be either warm or cold, depending on the day, and the effect you want. For cool effects, I use a mixture of paynes grey, cerulean blue, and zinc white. For the warm misty effects, I use paynes grey and, sometimes, Davy's grey, yellow ochre, zinc white, and a little oxide of chromium, which gives it a warm yellowish-green effect.

In *Fog Drifts Inland* the mist is warm and damp as it is in summer, and was painted in the warmer colors. The trees are indicated with paynes grey, a little umber, and some of the fog mixture. Since the latter constitute most of the local color of the painting, it was added to the background and middle distance. The foreground, however, was painted with stronger colors—in this case, deep shades of oxide of chromium, raw sienna, umber, and touches of cadmium orange and yellow ochre. The effect is a grey painting with only slight areas of broken color in the foreground.

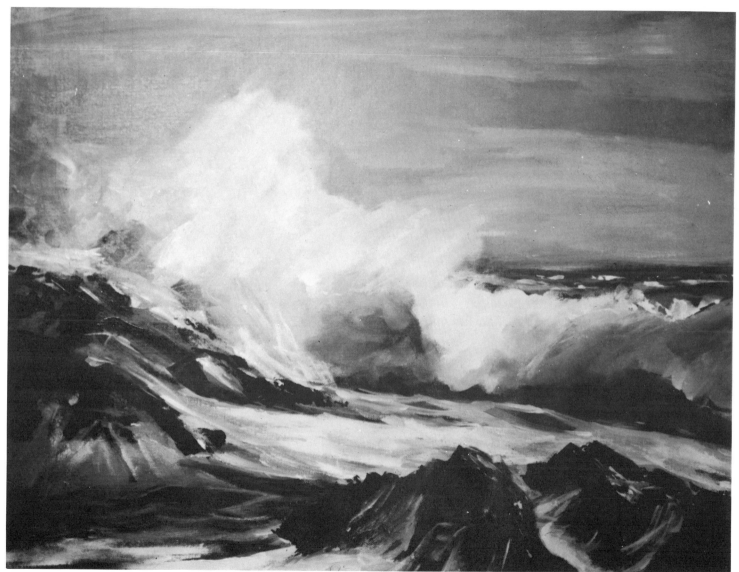

November Seascape

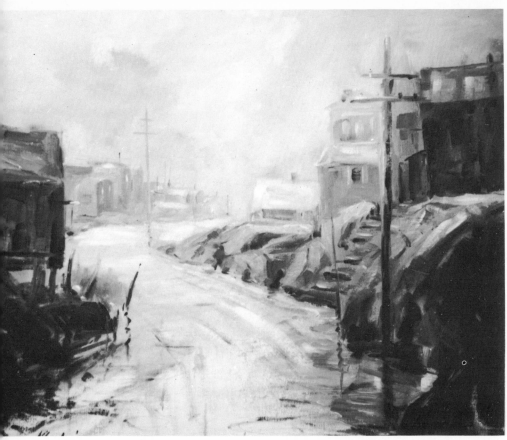

Quarry Point Road.

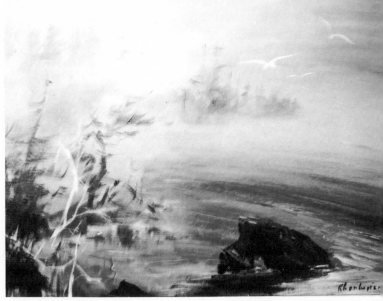

Morning Mists.

30

Driftwood: Beach Scene.

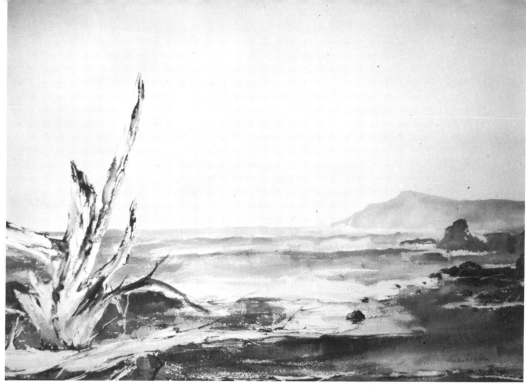

Conclusion

Do not be discouraged by your first attempts. The sea and sky can be more than a little overwhelming to anyone painting them for the first time. Understanding of the subject, and a technical ability to interpret it will not come all at once.

The notes and observations presented here have been compiled from many months of both sketching and just looking. I hope that by pointing out some of the basic principles and, by giving you the benefit of my experience, you will have gained a head start and will be able to avoid at least some of the pitfalls.

There are so many enjoyable things to draw and paint around the sea coast—you will never be limited or restricted by lack of material or subject matter. Look for the interesting textures found in rare old driftwood aged piers, and weatherworn boats. These things may be painted for their own intrinsic beauty or, without any knowledge of the subject matter itself, merely suggest abstract themes reminiscent of that time and place. Once you have learned the fundamentals, you will make these discoveries for yourself, and find your own way of expressing them.

The sea and sky can be a source of inspiration to everyone, but only you, as a creative artist, will be able to relate that vision to your own experience.

About the Author

Jean Khanbegian was born and brought up on Nova Scotia's rugged sea coast. It was this environment, and the advantage of a cultural background, which strongly influenced her to paint and draw familiar scenes at a very young age. Her earliest training in art began with the nuns in a private school. Later formal studies were carried on in New York, where she attended The School of Visual Arts, the Parsons School of Design, and The Art Students League.

Her work has been widely exhibited in the United States and Canada, and, in a recent New York showing of her work, art critic Michael Crain wrote in his World of Art Column for the *Gotham Guide*:

Painting with authority and persuasiveness, this well schooled artist captures the mood and drama of the sea with compelling results. The skills and lucidity of her work prove her to be an artist of genuine distinction.

French Critic Saint-Evremond, writing for Les Arts in the *France-Amerique,* says:

"Jean Khanbegian's *November Seascape* truly captures the feeling of wind and waves"—

She has won many awards both in the United States and Canada, and is listed in the 1967 edition of *Who's Who in American Art*. At the present time she is director of the Ebb-Tide Gallery in Bar Harbor, Maine, and a contributing author on the staff of *The Artist* magazine.